C000212582

HARTLEPOOL

HISTORY TOUR

Dedicated to Eileen Wood

First published 2016

Amberley Publishing
The Hill, Stroud,
Gloucestershire, GL5 4EP
www.amberley-books.com

Copyright © Paul Chrystal,
Stan Laundon & Simon Crossley, 2016

Map contains Ordnance Survey data ©
Crown Copyright and database right
[2015]

The right of Paul Chrystal,
Stan Laundon & Simon Crossley to be
identified as the Authors of this work
has been asserted in accordance with
the Copyrights, Designs and Patents
Act 1988.

ISBN 978 1 4456 5581 9 (print)
ISBN 978 1 4456 5582 6 (ebook)

British Library Cataloguing in
Publication Data.
A catalogue record for this book is
available from the British Library.

Typesetting by Amberley Publishing.
Printed in Great Britain.

INTRODUCTION

Hartlepool History Tour is a kind of 'best of' book: it takes the best bits from our three books on Hartlepool, puts them all together and produces this – a compilation of the most intriguing and revealing photographs of 'old' Hartlepool, West Hartlepool and Hartlepool. The previous three books – *Hartlepool Through Time*, *Hartlepool Through the Ages*, and *Hartlepool: The Postcard Collection* – have all been very popular. So much so that it was decided to publish this 'greatest hits' and satisfy the enduring demand for Hartlepool nostalgia.

The book, as the title suggests, takes the form of an illustrated tour, a tour which takes in the most important aspects of Hartlepool's history. You can use the book as a guide and take it with you on a journey through time from Seaton in the south to the Headland in the north; or you can just sit at home and read through it a leisurely pace with a cup of tea or a pint or two of Cameron's. You might live in Hartlepool or you might just as easily have grown up there and moved on, anxious for the nostalgia and memories this book can provide. Either way, this is the perfect guide to the three towns that are now Hartlepool.

The book takes you from the spectacular fun-fair resort that was Seaton Carew, to the buzzing shopping streets clustered around Church Street, from the promenade at the Headland to the Church of God in Greatham. It takes in long-gone

factories such as Cerebos, the Match factory, the Lard factory and the munitions works; it visits the fish quay, the shipyards, the steel works and the docks - all symbolic of a proud and noble industrial and commercial history – but still a symbol of England, all the same.

My two co-authors deserve much credit. Since working with me on *Hartlepool Through Time*, Simon Crossley has become my son-in-law – although I maintain that writing books with me had nothing to do with his marriage to one of my daughters. Stan Laundon took some wonderful, vivid photos for that book and for *Hartlepool Through the Ages*, lending both a great quality which goes a long way to ensure their ongoing popularity; he is, of course, a font of all knowledge on all things Hartlepool and his wisdom shines through, particularly in our *Hartlepool: The Postcard Collection*.

Finally, I have dedicated this book to Eileen Wood. For many years, Eileen was a close and constant friend of my family's when we lived as neighbours in Hartlepool. She loved life and, along with her husband Bill, made life better for anyone who had the good fortune to come into contact with them.

Paul Chrystal, York January 2016

ACKNOWLEDGEMENTS

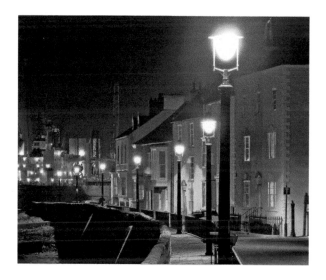

Old Hartlepool by night.

Thanks to Owen Corrigan, George Colley, Anita Roberts Tyzack, Jacki Winstanley of the People's Collection at Beamish Museum, and Jane Whittaker at the Pattison Collection at Bowes Museum, Barnard Castle. Sandra McKay, Anna Dodgson and Charlotte Taylor at Reference Services, Hartlepool Borough Council and Bill Henderson.

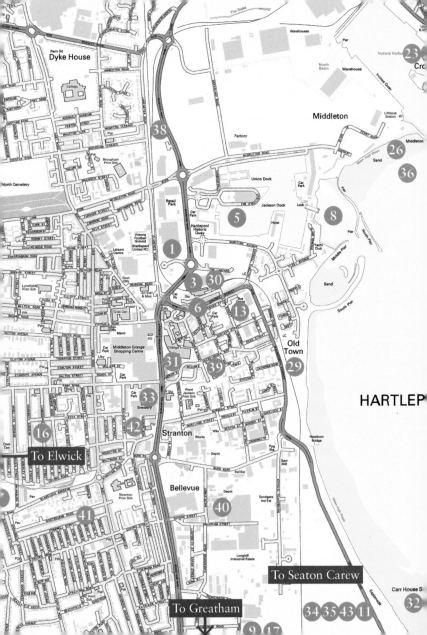

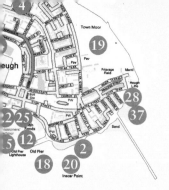

Town Moor

19

Pav

Pav

Friarage Field

Ment

Heugh

eugh

Bull Ring

28

37

22 25

Fish Sands

issioners' bour

12

Sand

15

Old Pier Lighthouse

Old Pier

2

18

20

Inscar Point

pool Bay

Long Scar

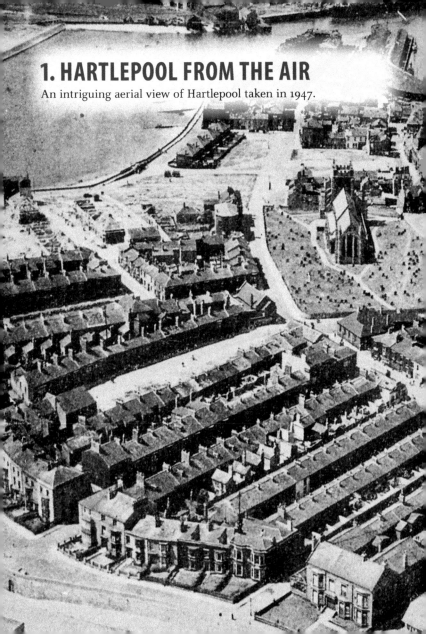

1. HARTLEPOOL FROM THE AIR

An intriguing aerial view of Hartlepool taken in 1947.

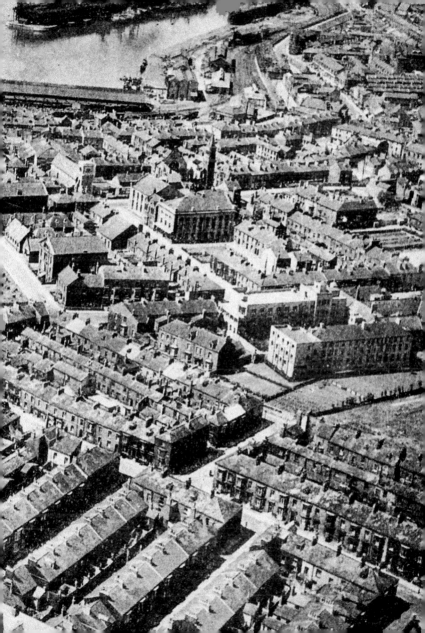

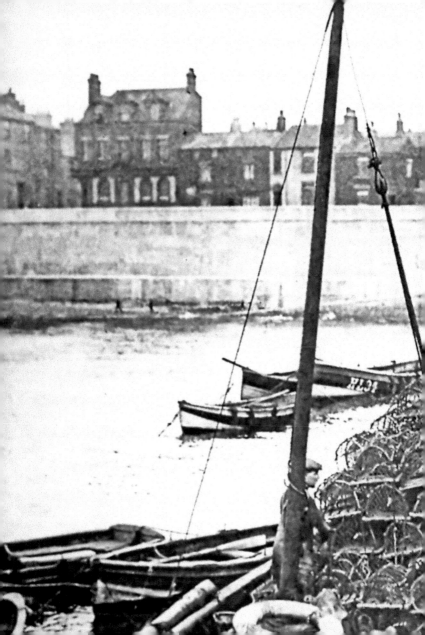

2. THE OLD PIER

A busy day on the old pier in the 1940s with fishermen loading pots.
The door of the joiner's shop is open and a door to the blacksmith's
can be seen on the right.

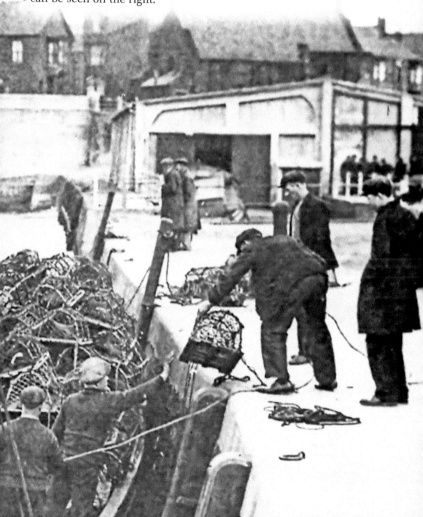

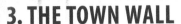

3. THE TOWN WALL

The walls were built in the fourteenth century to defend the landward western side of the peninsula and the beach on the south side. This fortified the harbour and made Hartlepool one of the most heavily defended port towns in Britain, and the only walled town not to have a castle. The wall had three gates: one on the road to Hart, Northgate, which protected the main route into town; Watergate gave access to the harbour and Sandwell Gate, the only one to survive, provided access from the Fish Sands through the south wall. Three further gates were added later.

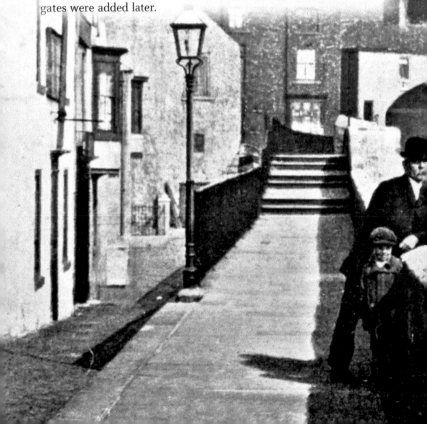

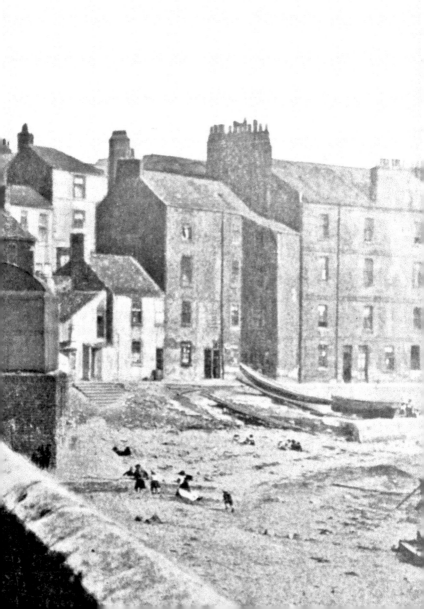

4. THE TOWN WALL

I've been in a few bars in my time, and many would say that a bar is a bar anywhere (except in York where, oddly, a bar is a gate) – but this is obviously not the case. The bar of The Harbour of Refuge is truly exceptional, as you can see here. Built in 1895, it was preceded by a beerhouse-cum-grocers. It is known as The Pot House on account of the glazed pottery tiles on the outside walls.

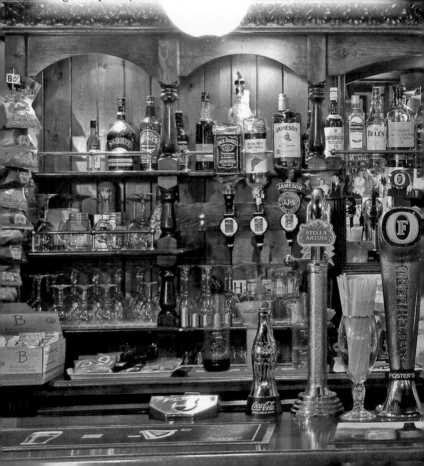

5. THE FISH QUAY

The jawbone and a vertebrae of a baleen whale netted off Hartlepool in the early 1930s. The sailor on the left is Frederick Arthur Abigail, who was a mate or third hand on a number of Hartlepool trawlers; he is the fifteen-year-old third from the left in the main photograph. Frederick was on minesweepers during the Second World War and shot down an attacking German fighter in 1940; he was awarded the DSM.

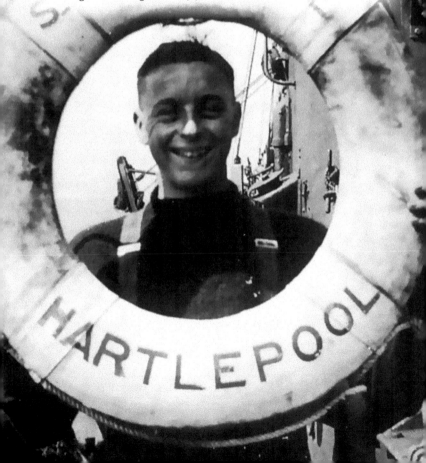

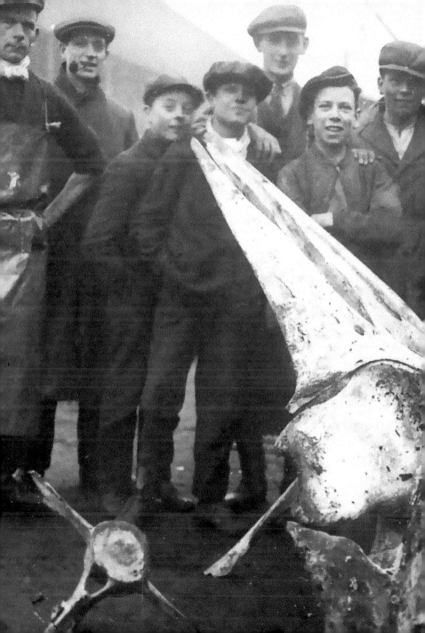

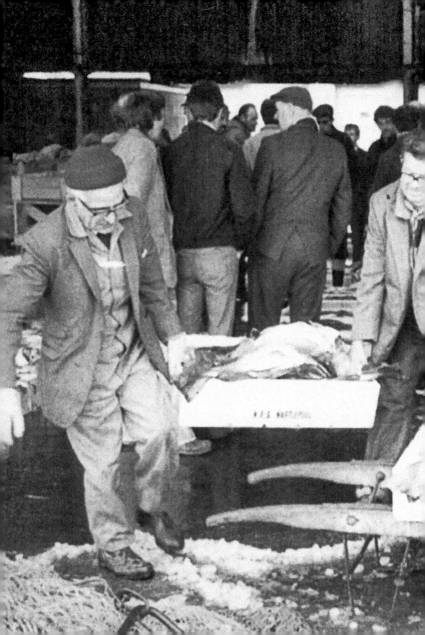

6. THE FISH QUAY

Lol Richardson (on the left) doing the hard work during an auction in the 1970s. Working the auctions, or 'reading the markets', at the quay to obtain the best price required skills and intuition as sharp as any found on the trading floors of city financial institutions. When the fish was sold and the tallies applied to the boxes, they were moved to the fish merchants where it was sorted and boxed according to destination in the UK. Lids were nailed down and destination tallies were affixed before the boxes were loaded on to the appropriate railway trucks. Before the introduction of filleting, fish were always dispatched whole. Lol Richardson was my uncle. My Aunt Doreen, 90 something, still lives in Elwick.

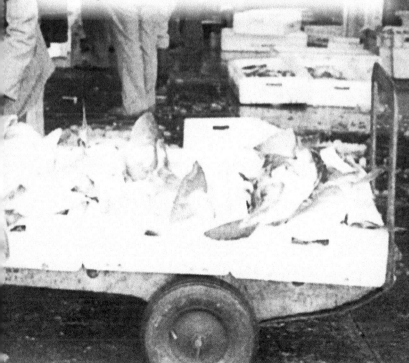

7. FISH SANDS

A marvellous old picture taken from Pilot's Pier and showing Lisle's Flour Mill on the left; the chimney was demolished in 1900, but the mill itself lived on until the destruction of the Croft in 1938. The pub in front of the mill is the Freemason's Arms, which was a lodging house run by Jane Hunter before that according to the 1851 census. The pub was demolished in 1905. The tenement-like buildings in the centre are Cambridge Buildings named after their builders, John Cambridge and his father; the Cambridges were local boat and coble builders. Behind the double doors to the right was the lifeboat; Pier Street is on the far right. This photograph predates the construction of the 'battament', the walkway along the lower wall, which still survives today. This photograph predates the construction of the walkway along the lower wall.

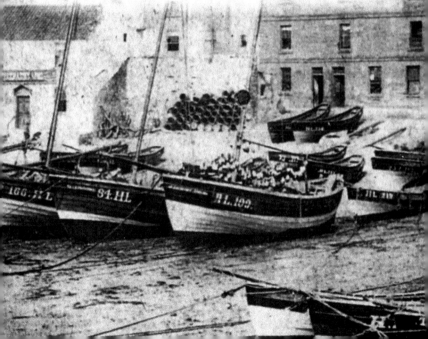

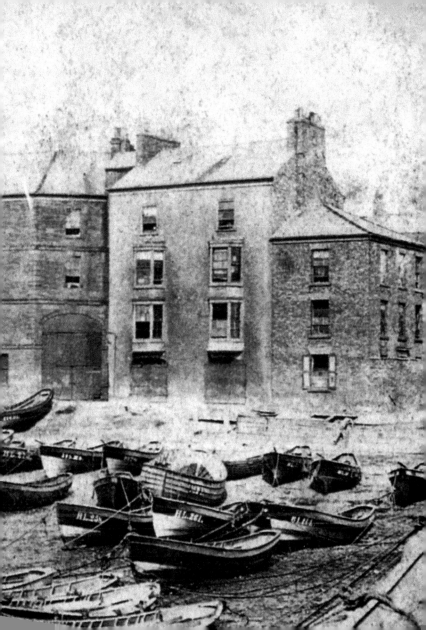

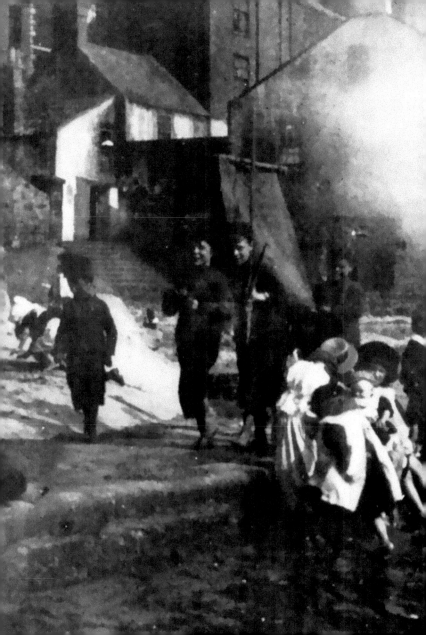

8. FISH SANDS II

This idyllic photograph speaks for itself. The Freeman's Arms is the white building behind the children with Cambridge Buildings behind that; Pilot Pier is at far right. Today the Sebastopol Cannon stands near the lighthouse and Heugh Battery. It was captured from the Russians at the battle of Sebastopol during the Crimean War (1854–56). In 1857, the Secretary of State, Lord Panmure, offered the cannon to Hartlepool and it was duly shipped from London at a cost of £2 19s 3d, arriving in September 1858. It is one of many artillery pieces from down the ages still guarding the Hartlepool coast.

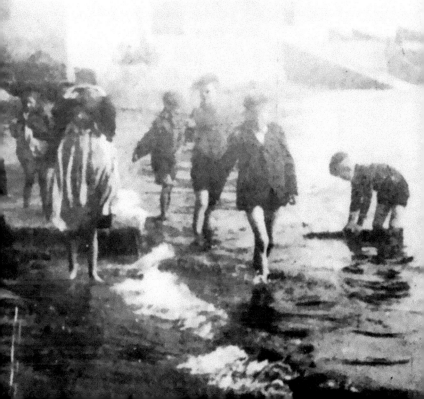

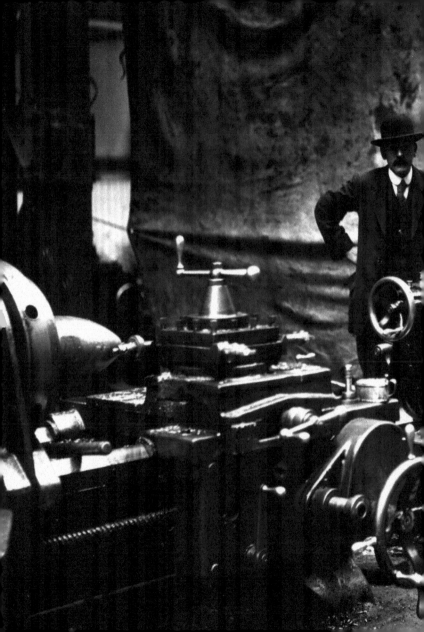

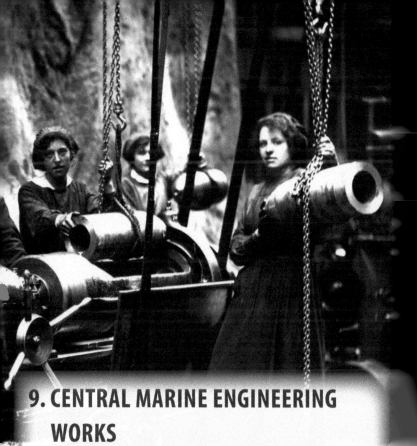

9. CENTRAL MARINE ENGINEERING WORKS

A National Shell Factory for the production of 8-inch shells was established in converted boiler shops at the Central Marine Engine Works between July 1916 and the end of December 1917. Most of the workers were women who were involved in every part of the production process, from operating overhead magnetic cranes and hydraulic presses, to the high-precision work of boring, turning and milling shell cases. The image shows fixing the boring shell nose and thread milling for the fuse.

10. PROMENADE

5 June 1912 was not a good day for the SS *Otra*; she was wrecked off the North Sands. The *Otra* was but one of many ships wrecked off Hartlepool, perhaps the worst night was the Great Storm of 9 February 1861 when sixty vessels were wrecked or beached between the Old Town Pier and Seaton. One of the casualties that night was the Rising Sun whose figurehead graces the White Hart at Hart. The picture shows salvage work going on.

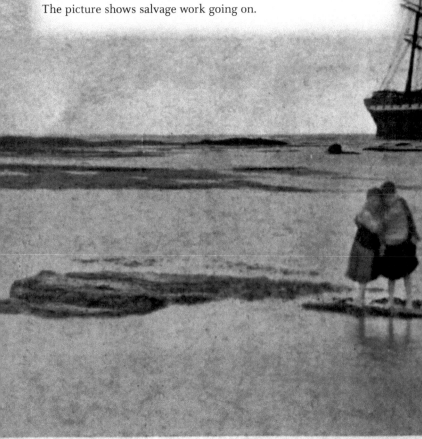

Norwegian Sailing Ship "Otra," ashore at Hartlep

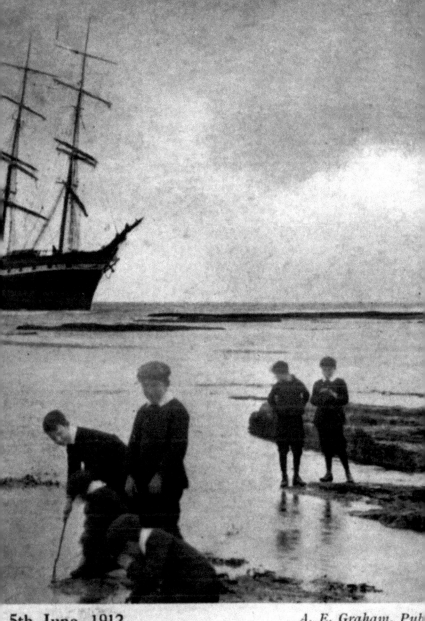

5th June, 1912. A. E. Graham, Pub

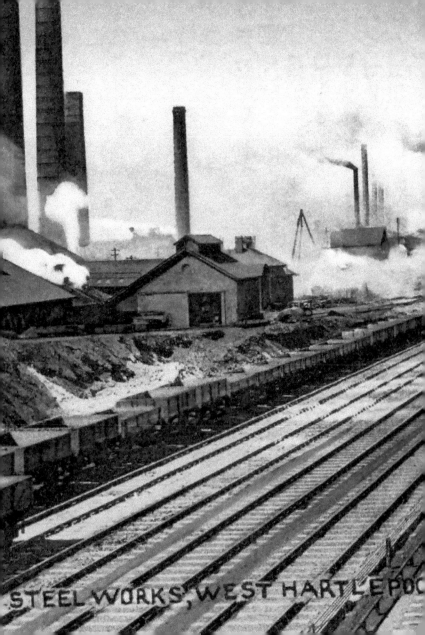

STEEL WORKS, WEST HARTLEPOOL

11. CLIFF HOUSE JUNCTION

In 1955, Arosa Hosiery Manufacturing Co. took over the Pyramid Plastics button factory on the Hartlepool Trading Estate. This picture shows the rail approach to the steelworks with coal trucks parked on the left.

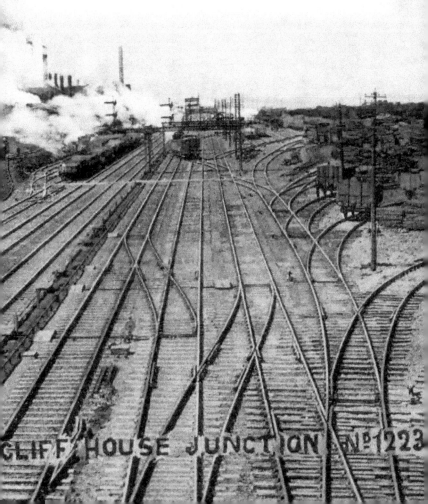

12. CLARENCE ROAD

The Queens Rink Ballroom in Clarence Road was where it was at during the 1940s, 1950s and 1960s and played venue for many bands and groups from those years. In this photograph everyone seems to be waiting for the next record to be played although there is obviously some badly concealed deliberation among the three boys in the foreground as to which of them will approach the two girls to their left. The Rink was built in 1910 as a skating rink; during the First World War troops were billeted there. It then became a garage and was later reopened in 1932 for skating and boxing and converted into a dance hall in 1940. It closed in 1968 and was demolished some years later.

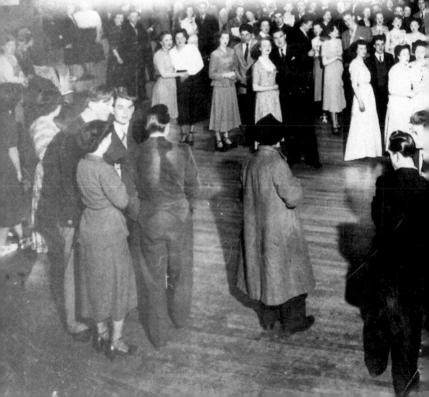

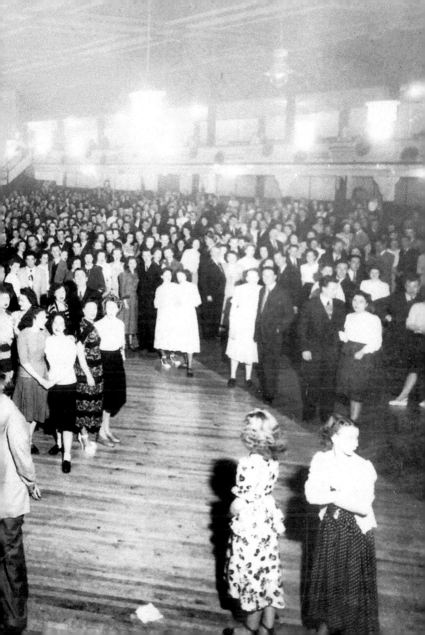

13. ALBION TERRACE

As he have seen 5 June 1912 was a bad day for the SS *Otra*; she was wrecked off the North Sands. This wonderful picture shows the (largely unofficial) salvage operation with hundreds of local residents replenishing their firewood stocks from the cargo of pit props.

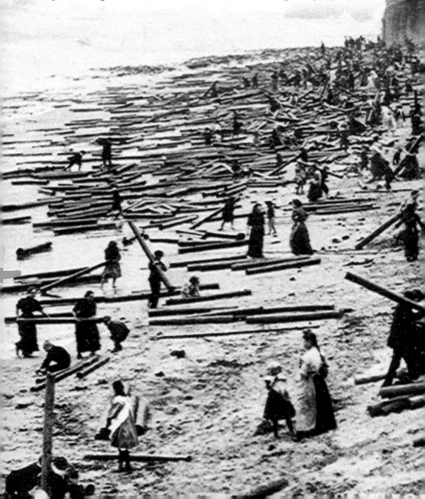

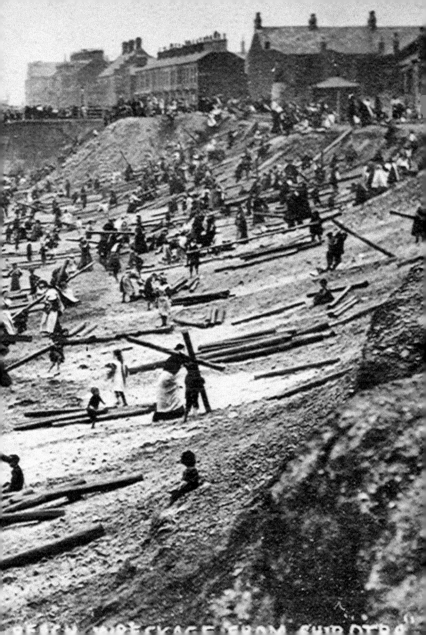
BEACH WRECKAGE FROM SHIP OTRA

14. CHURCH STREET

A graphic depiction of the Great Fire of 1922 which again could, at first sight, be mistaken for a scene from the bombardment. Hartlepool's other (non-wartime) big fire took place on 30 August 1954, when the North of England Match Company factory caught fire and was totally destroyed. Huge crowds gathered in Church Street to watch the blaze with some people even buying platform tickets at the station to get a better view. The company was established in 1932 and by 1954 was producing over thirty-two million matches per week. One early sales ploy was the insertion of five-shillings gift vouchers in selected boxes.

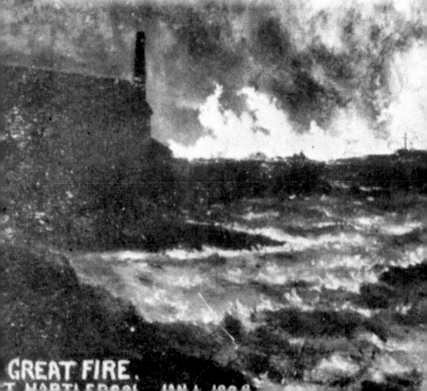

GREAT FIRE.

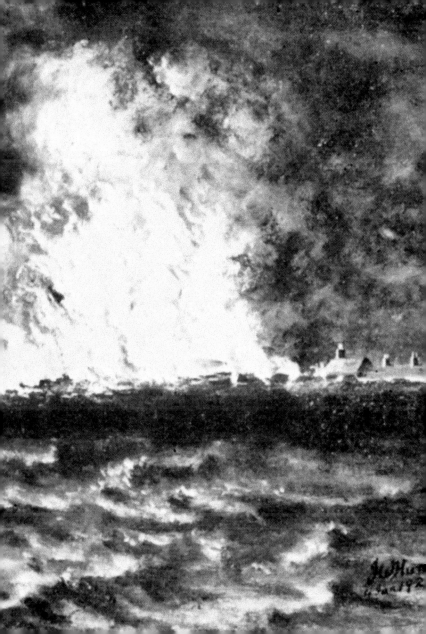

HIC · IACET · FRATER · HUGO · DE
HERTILPOL · ANGLICUS · MAG
ISTER · IN · SACRA · THOLOGI
A · QVONDAM · MINISTER · AUG
LIE · QI · OBIT · III · ID · SEPTE
MBR · ANNO · VIIJ · MECSEDO
ORATE · P · ANIMA · EJUS ·

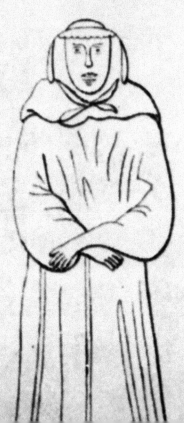

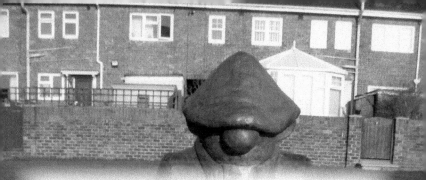

15. DURHAM STREET

Hugo is one of the first, if not the first, Hartlepool person to have left us a picture. He was from the Franciscan Friary, where Hartlepool's hospital once stood and went on to become proctor of Balliol College, Oxford. He died in Assisi in 1302, where his lectures are preserved and is buried close to St Francis himself. The image here is taken from the figure carved on his marble grave slab; the Latin inscription reads: 'Here lies brother Hugo of Hartlepool, Englishman, teacher in sacred theology, one time English minister, died September 4th 1302; pray for his soul.' The modern picture is of another famous Hartlepool character: Andy Capp, the creation of Hartlepool-born Reg Smythe for the *Daily Mirror* and the *Sunday Mirror* since 1957. The name is a double pun on 'handicap', which is what he is to Flo, his long-suffering wife, and on his 'handy' cap. The trademark cigarette and occasional sparring with Flo were airbrushed out in the 1980s in the interests of political correctness – hence no fag end in the statue, which proudly stands near No. 37 Durham Street, Andy's home. He is syndicated to over fifty countries and translated into fourteen languages including Italian – Angelo Capello – and French – Andre Chapeau. In 2007, the bronze statue, by Jane Robbins, was erected near to the Harbour of Refuge public house and cost £20,000.

16. HARTLEPOOL HISTORIC QUAY

Most natives of Hartlepool have more or less gotten over the monkey-related jibes which occasionally come from neighbouring towns and rival football supporters, and they now embrace the legend as an integral part of their local heritage. Indeed, one of the local Rugby Union teams, Hartlepool Rovers, is proudly nicknamed The Monkeyhangers, even going so far as hanging a stuffed monkey from every crossbar on one tour; Hartlepool United F.C.'s mascot is a monkey called H'Angus the Monkey – famous nationwide for his occasional 'inappropriate' behaviour. In 2002, Stuart Drummond ran for the office of Mayor of Hartlepool dressed up as H'Angus – and won; his election slogan was 'free bananas for schoolchildren', and, although this was one pledge too far, he has since been re-elected twice in 2005 and 2009, and is the first elected mayor in Britain to win a third term.

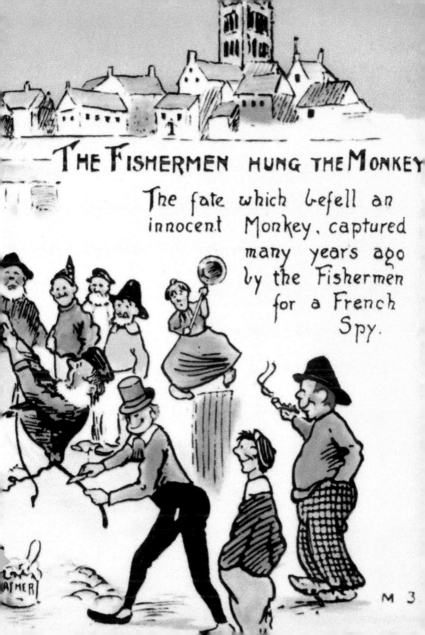

THE FISHERMEN HUNG THE MONKEY

The fate which befell an innocent Monkey, captured many years ago by the Fishermen for a French Spy.

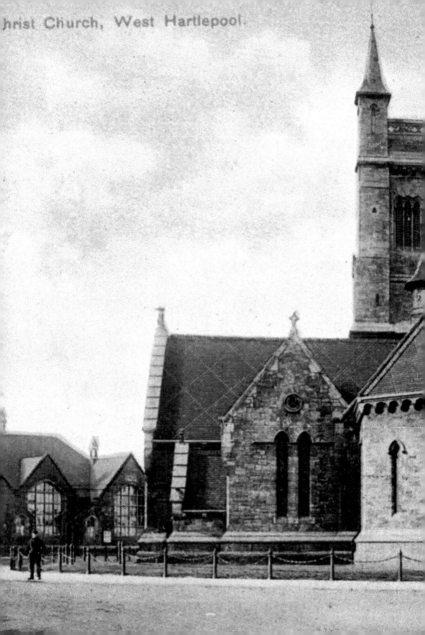

hrist Church, West Hartlepool.

17. CHRIST CHURCH

Christ Church was the first church to be built in West Hartlepool, in 1854, by Ralph Ward Jackson at a cost of £6,000 with an extra £400 for a peal of bells. It is built with magnesium limestone excavated from Jackson's docks. The altar rails were remarkable in that they are made from bog oak recovered from the excavated ancient forest at the bottom of the docks. The building to the left of the church is the West Hartlepool Public Undenominational School, established as a result of the feud between Ward Jackson and the Revd John H. Burges, who wanted the church school to be exclusively for the children of church going families. Ward Jackson stands sentinel in the foreground; he was knocked off his plinth by a bus in 1957. The bronze statue was presented to the town by Colonel John Cameron in 1897 and was unveiled by Charles Stewart Vane-Tempest-Stewart, 6th Marquess of Londonderry, in front of a crowd of 2,000 people. Today the church is home to the Gray Art Gallery.

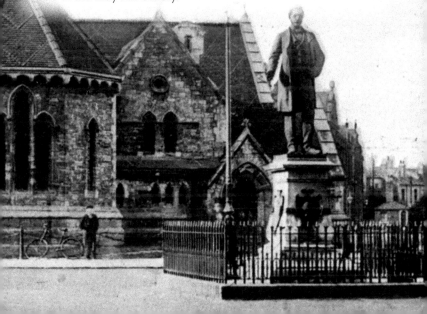

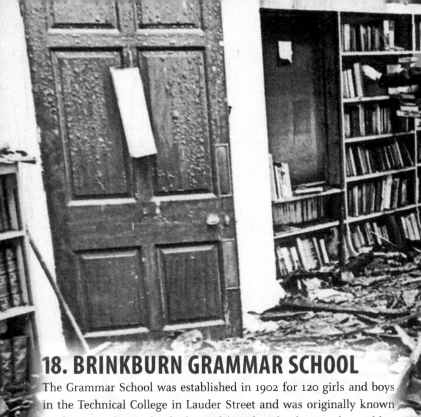

18. BRINKBURN GRAMMAR SCHOOL

The Grammar School was established in 1902 for 120 girls and boys in the Technical College in Lauder Street and was originally known as the Secondary School; the Girls' High School opened on Eldon Grove in 1911, leaving the boys to their own devices. In the 1930s, the Grammar School decamped to Brinkburn and became known as Brinkburn Grammar School. The main buildings were a converted nineteenth-century merchant's house. A major fire in May 1967 devastated part of the school and caused more than £30,000 worth of damage. It was restored and became the Upper School of Brinkburn Comprehensive School in 1973; the site is now occupied by Hartlepool Sixth Form College.

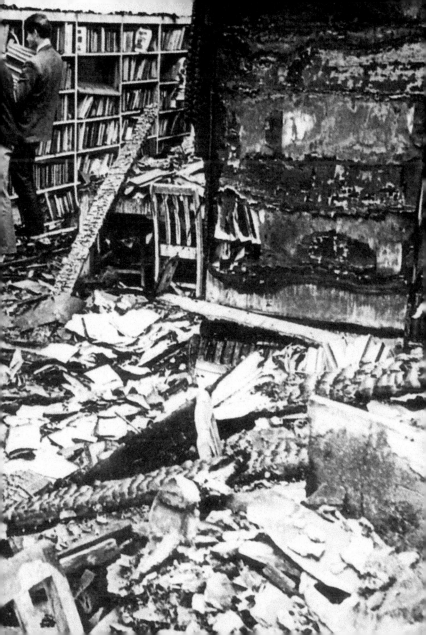

19. WEST HARBOUR

The launch ceremony for the *Manchester Importer* in May 1899 with guests dwarfed by the immense size of the vessel. It was built by Irvine's for Manchester Liners and was the first of a two-ship order: the sister ship the *Manchester Shipper* was launched in 1900. Irvine's had been bought by Christopher Furness in 1897.

20. CEREBOS – 'SEE HOW IT RUNS ...'

Staff in the female dining room at Cerebos, Greatham, during a religious meeting. The extraction and processing of salt has a long history around here: George Weddell, a pharmacist whose first plant was at Seaton, bought the 1894 Greatham Salt & Brine Company and founded Cerebos in 1903; here he drilled to a depth of 1,300 feet to extract the salt. Before free running salt was available, household salt was bought in slabs: Weddell, while looking for a cure for his daughter, who was ill with a form of osteoporosis, extended research carried out by George Duncan Bowie and serendipitously added magnesium carbonate and calcium phosphate to salt. This kept it dry and ensured it was free running; he then launched Saxa Salt in 1907. Weddell hit on the name Cerebos because it was a compound of the Latin name for Ceres, Roman goddess of the harvest, and *os*, Latin for bone. Bisto Gravy Salt followed – developed by employees Messrs Roberts and Patterson, whose wives had complained about how hard it was to make good gravy. In 1919, Cerebos Ltd acquired Middlewich Salt Co. Ltd, giving them a total workforce of 850 women and 150 men. The salt stopped running when the company was acquired by RHM Ltd in 1968, which in turn was acquired by Premier Foods in March 2007. The factory now lies empty and dilapidated.

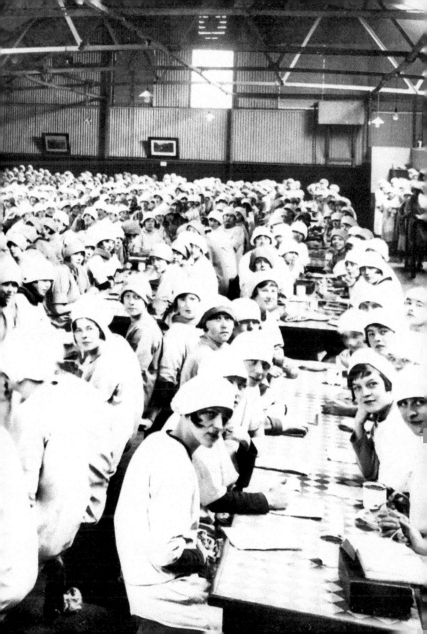

21. GREATHAM HOSPITAL OF GOD

Greatham Hospital of God was first established around 1264 by Bishop Stichell of Durham as a sanctuary for five priests and forty poor laymen. It is dedicated to God, St Mary and St Cuthbert. The arched façade dates from 1804. The statutes or ordinances follow: 'Andrew de Stanley, Priest, shall be the first Master, and there shall be perpetually maintained five other priests and two clerks, of honest life and competent learning, to sing matins ... and forty poor brethren to be chosen from the most indigent within the manors of the Bishop ... the poor brethren shall have a competent house to eat and to sleep in; they shall be chosen of the most infirm and indigent, without other preference. The Master shall have the power of ejection... Those who are able shall attend mass-hours in the Chapel, and let the infirm lie in their beds and pray as they may.' From Robert Surtees: 'Parish of Greatham', *The History and Antiquities of the County Palatine of Durham: Volume 3: Stockton and Darlington Wards* (1823), pp. 134–143. In 1353, it was decreed that the Master would grant to each brethren seven white loaves and seven pitchers of ale weekly, for life. From 1761, women were cared for too.

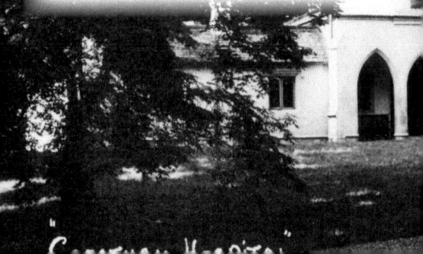

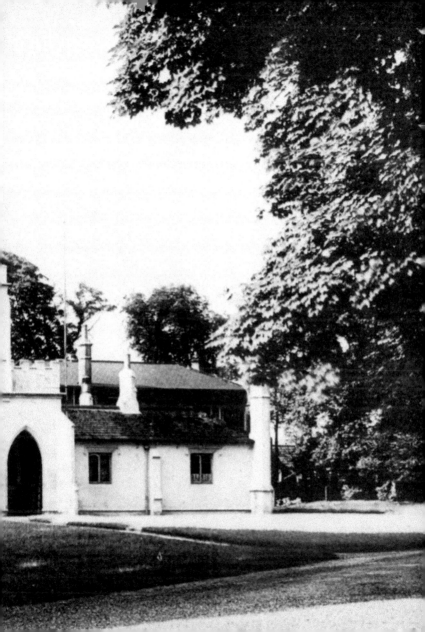

22. LYNN STREET, 1895

West Hartlepool's main shopping street for many years, this view looks north from Reed Street towards Church Street; McEwen's, drapers, is on the left and S. S. Eades, piano and music shop, is on the right. The gabled building further down is the Lynn Street Market designed by J. W. Brown, Borough Surveyor and Engineer around 1893. In addition to lock-up shops in the hall and ten rows of market stalls, the market had shops fronting on to Lynn Street. The market yard was behind the hall, designed as a cattle market but, more often than not in winter, used by travelling showmen to paint and refurbish their equipment.

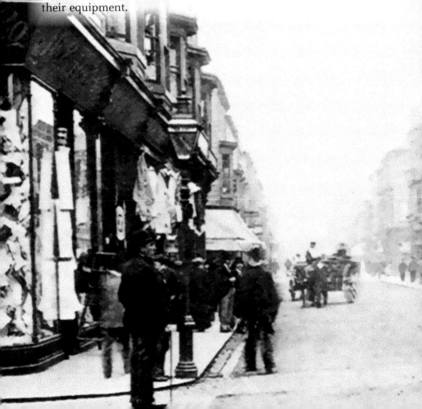

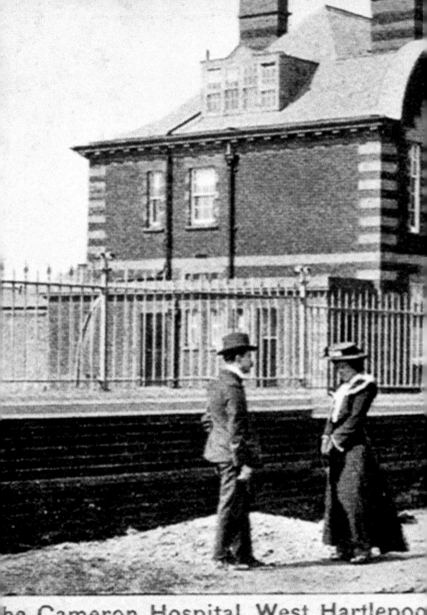

he Cameron Hospital, West Hartlepool

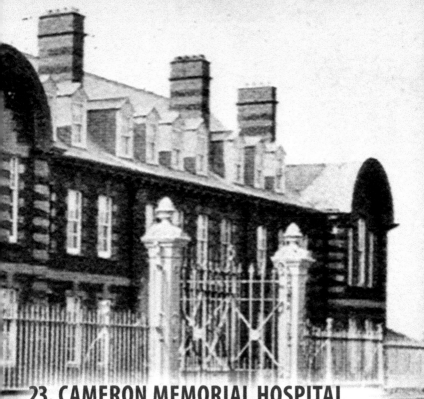

23. CAMERON MEMORIAL HOSPITAL

One of Hartlepool's greatest benefactors, brewery owner Colonel J. W. Cameron, bequeathed this hospital to the town in 1897 after his death. The total cost of the building and equipment was £20,480; it was opened on 29 April 1905 by Sir Christopher Furness MP. Originally a general hospital with forty beds split between male and female wards, it had one operating theatre and a maternity ward with twenty beds, which opened in 1931. It became a training hospital in 1933 and then, from 1955, a dedicated maternity hospital. Cameron Hospital closed in 1991 and was demolished soon after to give birth to a housing development.

24. SOUTHGATE

A fascinating 1860 view down Southgate towards Dockgates from the front of the Union Hotel (now Union House), showing characters in the dress of the day and some interesting properties. On the left, just in shot, are the offices of the *Mercury* newspaper, Holmes China Warehouse, James Murray ships' chandlers and J. Metcalf's Dock Hotel. T. Marshall's cordwainers is the shop in the centre of the photograph with the wonderful boot on the edge of the roof. The clay pipe smoking gentleman is Thomas Marshall, later Hartlepool Bellman; to his right, leading the horse and cart is John Kirk, a North Eastern Railway dollyman. These buildings were demolished in the 1870s. *The History of Hartlepool* describes the fishermen of Hartlepool, many of whom would have lived in the Croft, as follows: 'a hardy race of men...they are in general sober, and their luxuries seldom extend beyond the indulgence of fine white cakes; they marry early, have in general large families, and their wives are generally the purse-bearers.' The contemporary photograph shows one of the shops which form part of Hartlepool's Maritime Experience display around the Trimcomalee and are characteristic of the type of shop typically found in a port.

25. ELWICK VILLAGE GREEN

Taken around 1900, this picture shows the Spotted Cow on the right. Made up of a number of sixteenth- and seventeenth-century buildings, the village was made a conservation area in 1975. St Peter's parish church has a twelfth-century tower and chancel and a number of outstanding stained-glass windows. The other pub in the village is The McOrville, named after two famous local horses – Old and Young McOrville. An event which gruesomely connects Elwick, Greatham and Stranton is the 1569 Rising of the Earls – the unsuccessful attempt to put Mary Queen of Scots on the throne. Hartlepool was heavily implicated and while the nobility escaped with their lives by forfeiting their lands (for example, Robert Lambton of Owton Manor), the less privileged duly forfeited their lives: one rebel was hanged on the greens at Elwick, Greatham and Stranton, while four swung at Hart.

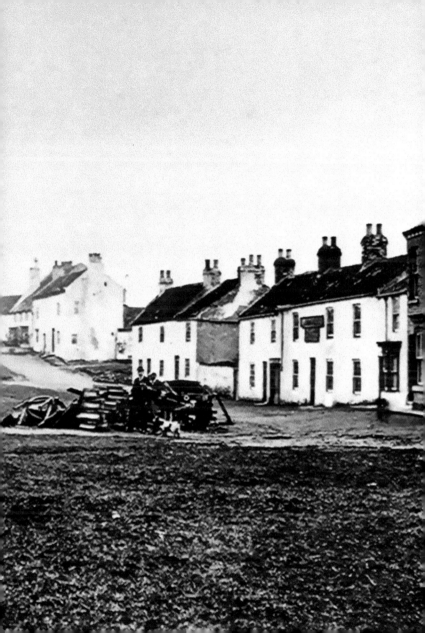

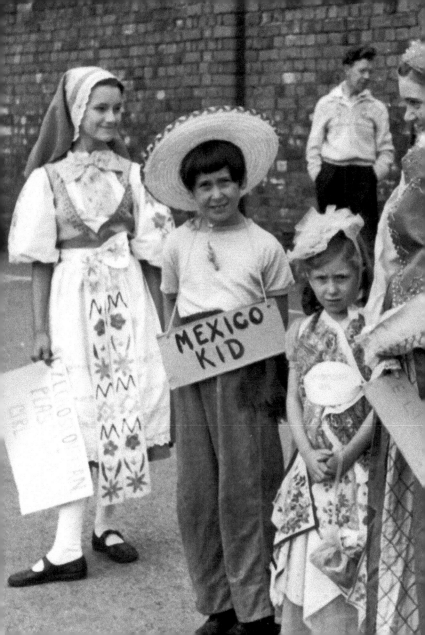

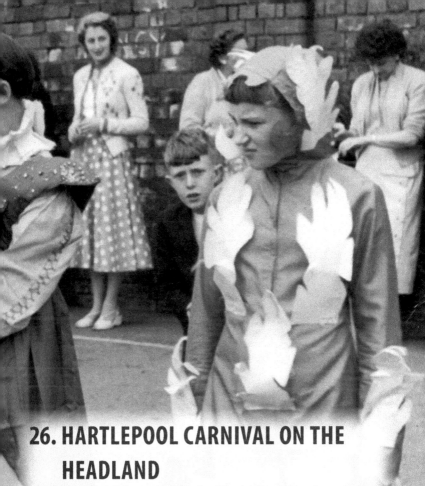

26. HARTLEPOOL CARNIVAL ON THE HEADLAND

A photograph of the carnival – the first in the 1950s, the second an altogether more dramatic and colourful event in 2013. The characters are, from left to right: June Stoddart, Phyllis Wanley, Ana Faint, Roslyn Wanley; the young boy is Keith Faint, with an unknown at the end. Ana Faint, mother of Ana and Keith, is on the extreme right.

27. NO. 18 NORTHGATE

The photographer is the focus of attention here. From left to right, you can see the corner of St Hilda's Hall, Church Close School, the Morison Hall, St Hilda's vicarage. On the right is part of the St Hilda's church wall.

NORTHGATE, HARTLEPOOL.

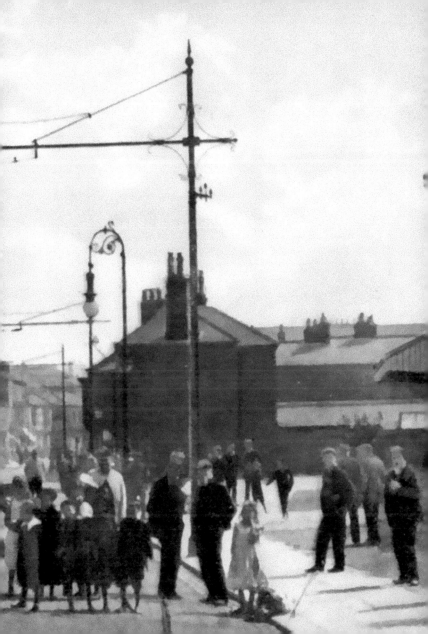

28. SANDWELL GATE

The word 'iconic' is vastly overused today to the point that is often utterly meaningless (a bit like 'nice'). However, if there was anything that could be called iconic in old Hartlepool then it is the Sandwell Gate. This atmospheric photograph was taken at the turn of the twentieth century.

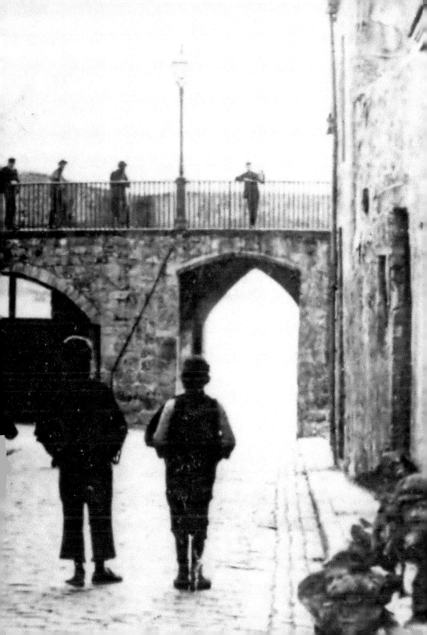

29. BREECHES BUOY PRACTICE

In 1931, two boys getting a close-up of the lifeboat crews perfecting this time-honoured, life-saving device on Middleton Sands. The picture appeared in my *Lifeboat Stations of the North East*, proceeds of which go to the RNLI; it was originally published in George Colley's *The Sands of Time*.

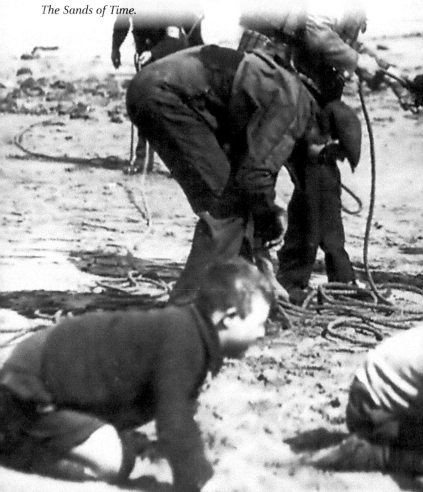

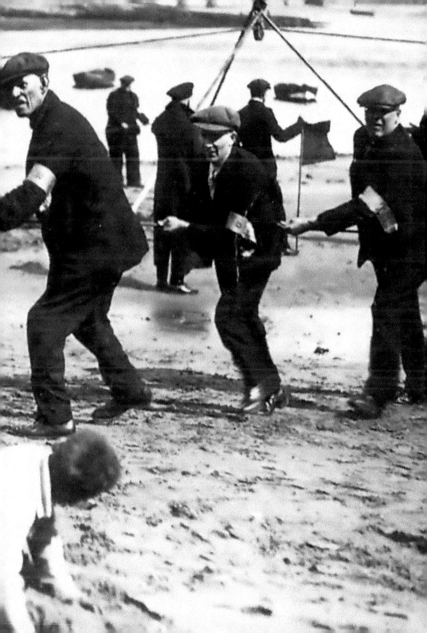

30. OLD HARTLEPOOL BY NIGHT

Pilot's Pier Lighthouse and the war memorial (*inset*) in Redheugh Gardens are resplendent at night. The Winged Victory (or Triumphant Youth) memorial remembers the 240 'Citizens, Servicemen and Servicewomen of the Borough of Hartlepool who gave their lives in conflict and War during the years from 1919 to 1967'. Those who died during the 1914 bombardment are also remembered.

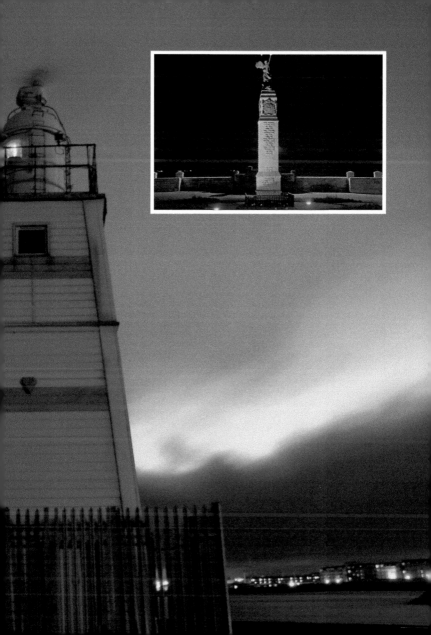

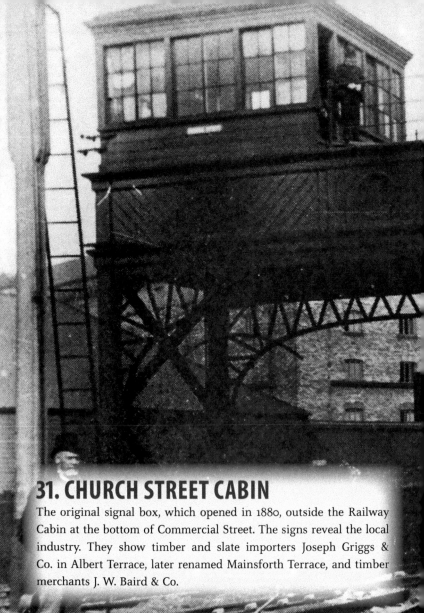

31. CHURCH STREET CABIN

The original signal box, which opened in 1880, outside the Railway Cabin at the bottom of Commercial Street. The signs reveal the local industry. They show timber and slate importers Joseph Griggs & Co. in Albert Terrace, later renamed Mainsforth Terrace, and timber merchants J. W. Baird & Co.

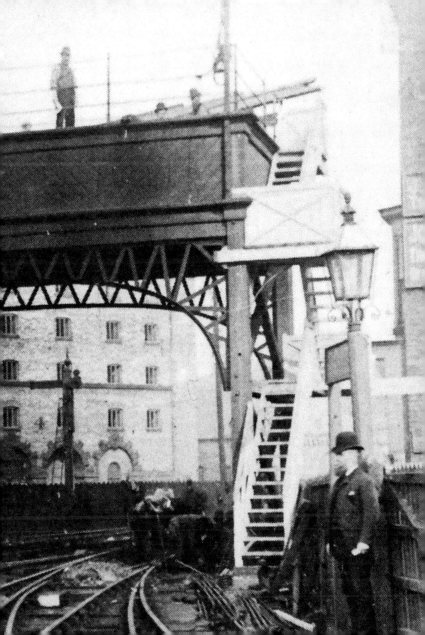

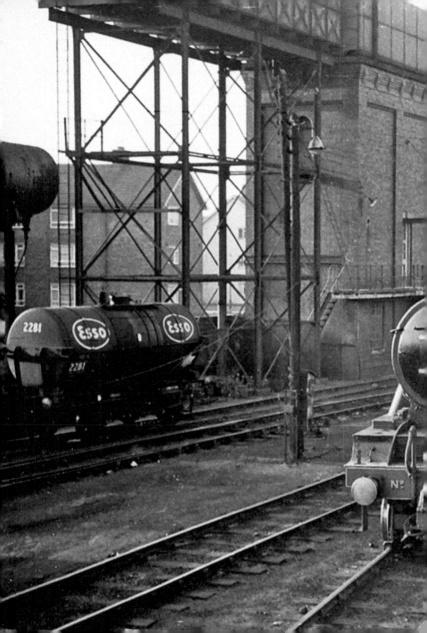

32. RAILWAY STATION

The A3 4-6-2 4472 (60103) *Flying Scotsman* leaving Hartlepool. She was the last steam engine to be watered and bunkered at the sheds in Mainsforth Terrace before they finally closed.

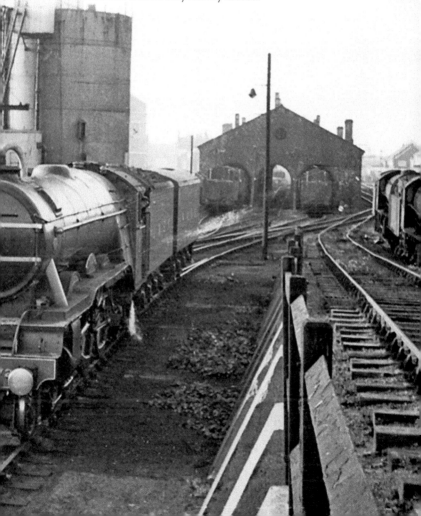

33. THE COLLEGE OF FURTHER EDUCATION, STOCKTON STREET

The fine building that is the College of Further Education is the latest in a long line of educational and training establishments on the site going back to 1897. Resources include an aircraft hangar housing two ex-RAF Jet Provost T5s, a Westland Gazelle Helicopter and a Rolls-Royce airliner engine; a sports science laboratory.

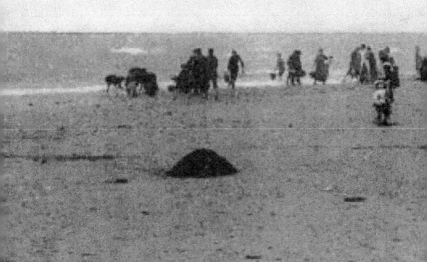

Gathering Sea Coal, West Hartlepool.

34. CARR HOUSE SANDS

A fascinating picture of sea-coal hawkers, plying their trade in 1912. Sea-coaling has been an integral part of life in Hartlepool since the seventh century: the tides erode coal from the sea bed, which is then washed up on the beach. A hawker can harvest more than a tonne of coal every day, which is then sold on to power plants. A full-page article entitled 'Boys from the Black Stuff', published on 9 April 2001 in *The Guardian*, described the Hartlepool sea-coaler's life; here is a short extract: 'No day is the same for the sea-coalers. They work the tides, and consequently find themselves heading for the foreshore at any and every hour of the twenty-four. Seven days a week. Theirs is the rota of the moon ... each seacoaler has had to learn to speak the language of the sea as fluently as any fisherman.' In October 2013, the council took steps to end the trade for the nineteen or so hawkers who still worked the beaches at Seaton Carew.

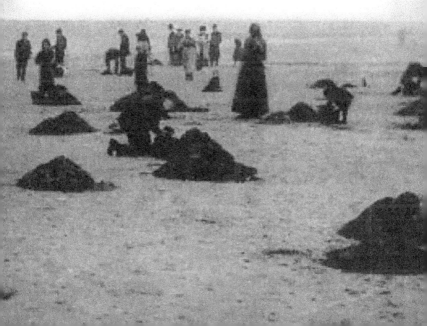

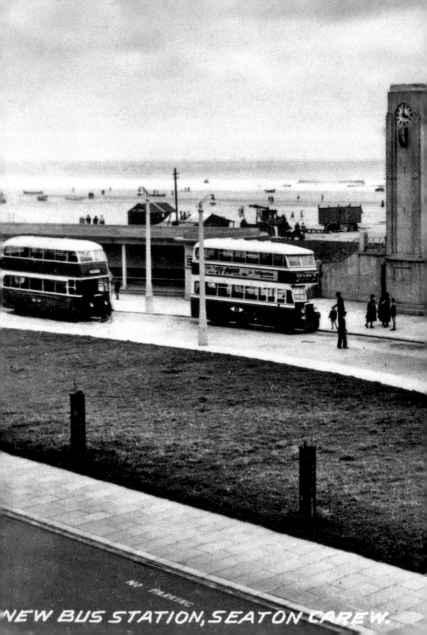

NEW BUS STATION, SEATON CAREW.

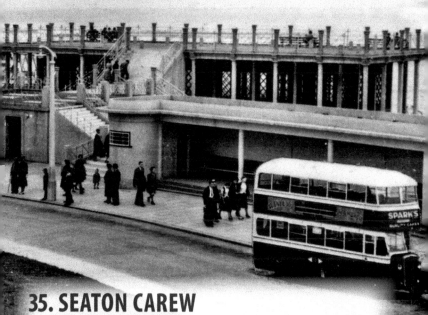

35. SEATON CAREW

A wonderful photograph showing this fine art deco Grade II-listed bus station, which opened in 1938. In November 1916, during the First World War, four Zeppelins attacked Hartlepool: one, the L34, was caught in a searchlight to the west of Hartlepool and Lieutenant Ian Vernon Pyott, a pilot with 36 Squadron based at Seaton Carew, pursued the Zeppelin for 5 miles, intermittently firing at his prey. The L34 caught fire and plummeted into Tees Bay with the loss of all crew.

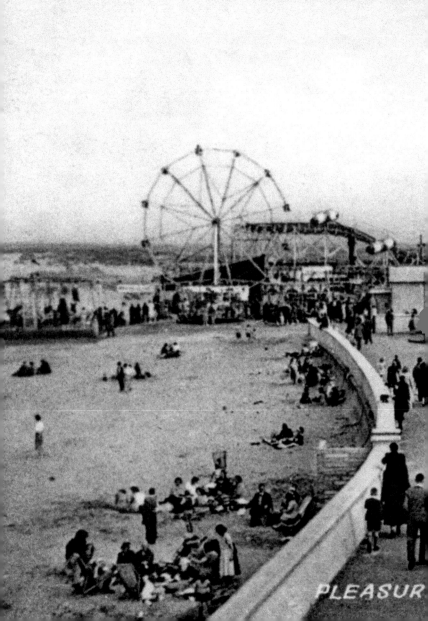

PLEASUR

36. SEATON CAREW

Seaton had to deal with Zeppelins in the First World War; in the Second World War it was the Luftwaffe's bombers; for example, on 6 January 1942 there were daylight machine-gun and bombing attacks at Seaton Carew; two high-explosive bombs were dropped on the Zinc Works; the works office was demolished, the distillation plant and a number of houses nearby were damaged and three people were injured.

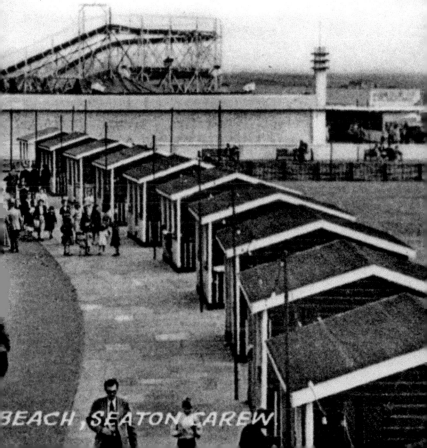

BEACH, SEATON CAREW

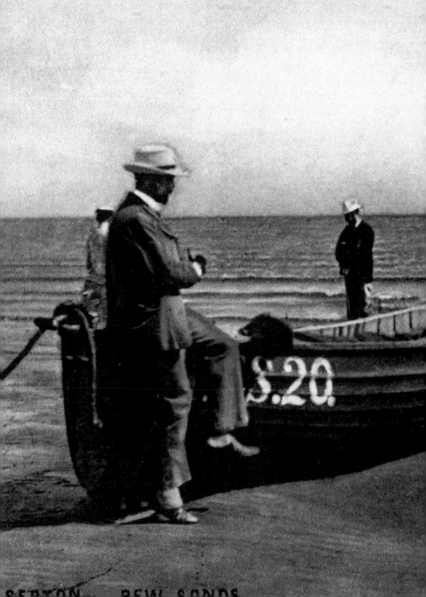

SEATON — NEW SANDS

37. SEATON CAREW

The resort is named after the Norman-French family de Carrowes or Carous, local landowners; Seaton simply means farmstead by the sea. Holy Trinity church was built 1831 at a cost of £1,700, the parish of Seaton came into being in 1841 when it ceded from Stranton. Two German Zeppelin pilots are buried in the graveyard; they were shot down on 27 November 1916, but not before they had dropped twenty-nine bombs.

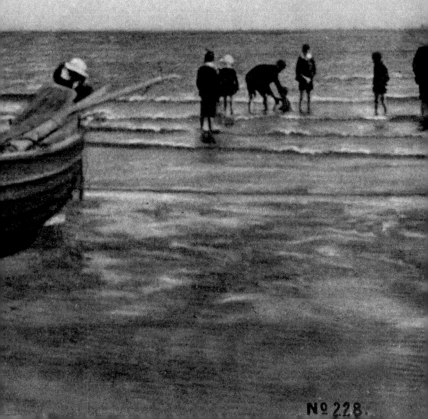

N° 228.

BEECHAM'S PI

38. SEATON CAREW

Bathing machines at Seaton sponsored by Beecham's in the summer of 1890. In 1897, there was some controversy: West Hartlepool Corporation considered that the segregated machines had been placed too close together by the owner, a Mr Lamb. Councillor Pyman reported that ladies had been deterred from bathing as a result and suggested that the machines be positioned 50 yards apart. Mr Lamb responded by saying that he had 'not received any complaints [and] such a condition would mean employing another man with horse and besides hardly any gentlemen bathed now'. The matter was sent to the Health Committee. The landlord who produced an advertisement copy promoting Seaton Carew in 1796 had no such qualms: 'there is not perhaps in this Island, at least in the North, a Place so well calculated for enjoying all the Comforts and delights resulting from SeaBathing, as Seaton Carew. The Bathing machines are removed with the utmost Facility, to any depth that may be required.'

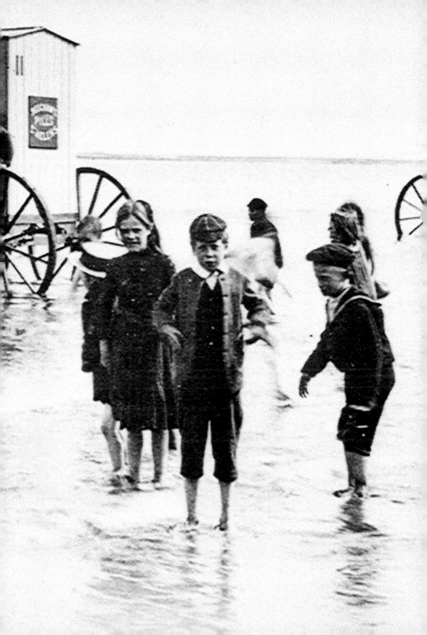

39. CAMERON'S BREWERY STOCKTON STREET

Cameron's chimney with the brewery smoking away, and the old Co-op building with Stranton church visible between the two; the photograph was taken from Christ Church tower.

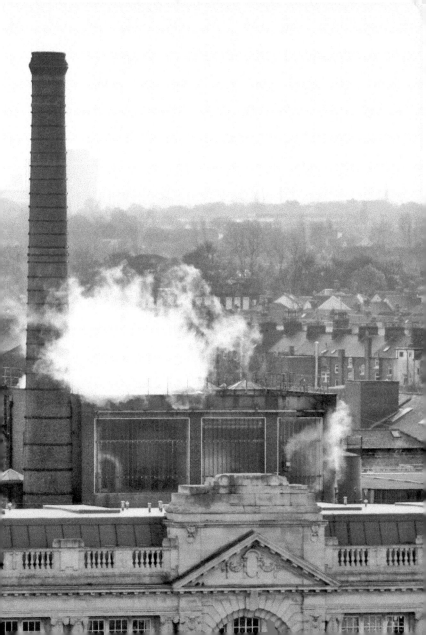

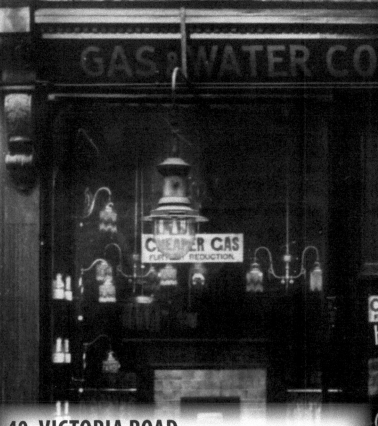

40. VICTORIA ROAD

A superb shop window on the corner of Victoria Road and Avenue Road, from the days when utilities suppliers made an effort. The Hartlepool Gas and Water Co., now Hartlepool Water, was established in 1846 with the first customers supplied with water from a source situated directly behind the company's existing offices (in Lancaster Road), providing up to 40,000 litres an hour.

PANY'S SHOWROOM.

CHEAPER GAS
FURTHER REDUCTION.

R GAS
REDUCTION.
EPOOL
S
ER
ANY.

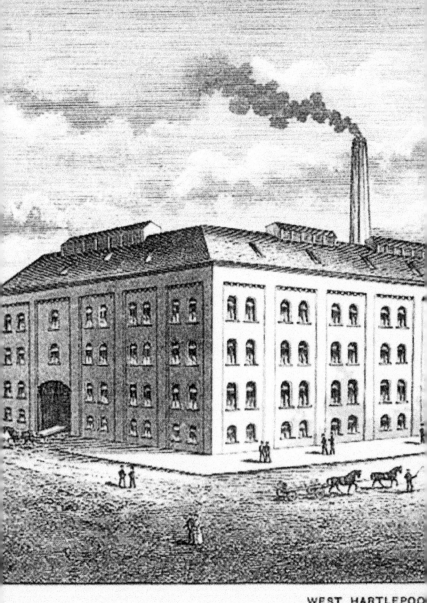

WEST HARTLEPOO
(See pages

41. OXFORD STREET

The lard refinery opened in 1883 on the corner of Oxford and Baltic Streets with a weekly output of 100 tons. An adjoining building was used for the production of pickled eggs. The complex was connected with the docks by a dedicated branch line, thus facilitating the importation of raw materials and the export of finished goods. It was sold to the Co-op in 1895, and the egg business was discontinued in 1904.

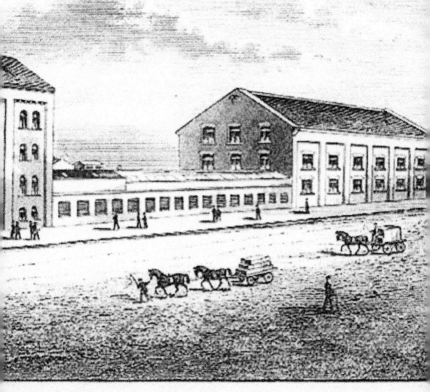

RD REFINERY.
d St.)

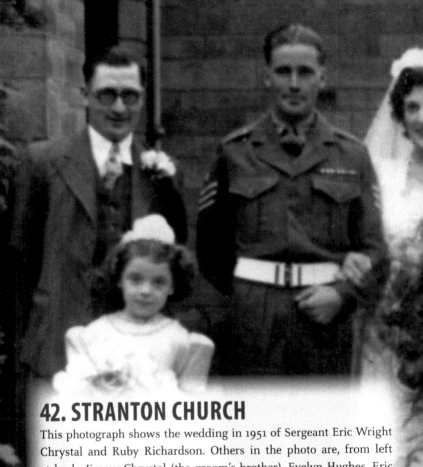

42. STRANTON CHURCH

This photograph shows the wedding in 1951 of Sergeant Eric Wright Chrystal and Ruby Richardson. Others in the photo are, from left at back: Jimmy Chrystal (the groom's brother), Evelyn Hughes, Eric Priest (the bride's uncle and son of Fred Priest, Sheffield United England footballer and player-coach of Hartlepool United), E; at the front on the left, Ann Gilhespy (née Richardson) and Irene McCready on the right – both nieces.

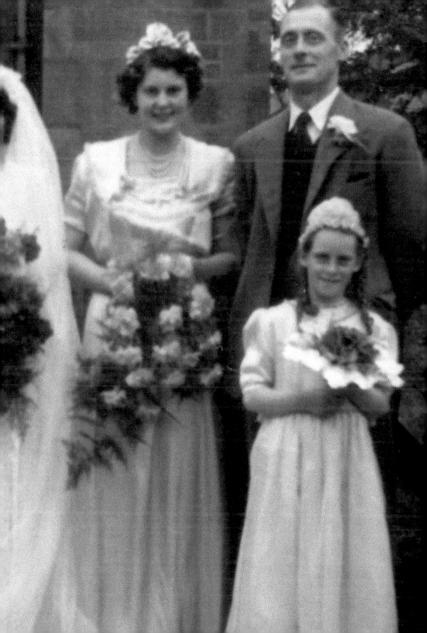

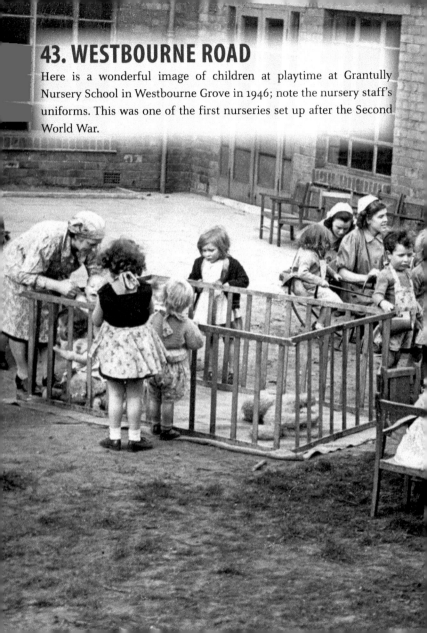

43. WESTBOURNE ROAD

Here is a wonderful image of children at playtime at Grantully Nursery School in Westbourne Grove in 1946; note the nursery staff's uniforms. This was one of the first nurseries set up after the Second World War.

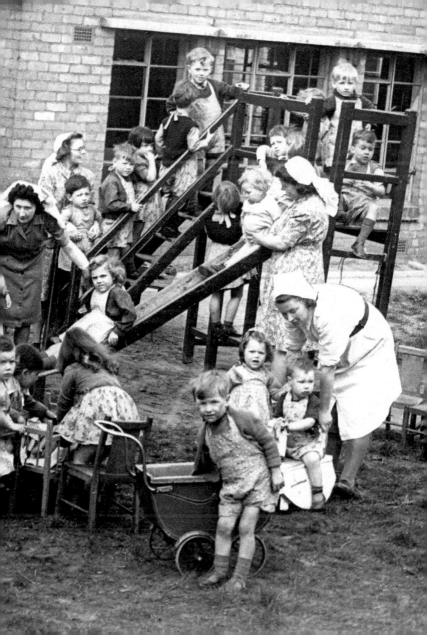

Also Available from Amberley Publishing

HARTLEPOOL

THE POSTCARD COLLECTION

STAN LAUNDON & PAUL CHRYSTAL

Also available as an ebook
Available from all good bookshops or to order direct
Please call **01453 847 800**
www.amberley-books.com

Also Available from Amberley Publishing

Paul Chrystal & Stan Laundon

HARTLEPOOL

THROUGH THE AGES

Also available as an ebook
Available from all good bookshops or to order direct
Please call 01453 847 800
www.amberley-books.com

Also Available from Amberley Publishing

PAUL CHRYSTAL & SIMON CROSSLEY

HARTLEPOOL

THROUGH TIME

Also available as an ebook
Available from all good bookshops or to order direct
Please call **01453 847 800**
www.amberley-books.com